Mind Vibe Awakening

Mind Vibe Awakening is the sequel to Mind Vibe. This book contains a series of poems, haikus and short stories written by author Kentrel James. The content in this book is designed to enhance the minds of the awakened and open the minds of those seeking to be awoken. Embark on this journey and let positive energy fill the atmosphere around you.

To my grandmother.
You are like a mother to me and I am forever grateful.
I thank God everyday for your guidance, love, kindness and wisdom.

The Awakening

Who am I?
I am more than my name

Who am I?
I am more than my body

Who am I?
I am more than my reflection

Who am I?
I am more than my thoughts

Who am I?
I am more than my actions

Who am I?
I am more than my emotions

Who am I?
I am eternal energy

3rd Eye Opened

I am an enlightened being
With an enlightened mind
With an everlasting enlightened soul

My brow chakra is unblocked
I am focused
I am relaxed

My creativity is boundless
My wisdom is infinite
I am centered on my true path

I harness the power of the law of attraction
What I desire is manifesting
Stress, anxiety and worry doesn't exist in my mind

Spiritual Traveler

It's quiet
Quiet and serene
Life's troubles don't exist here

Body at rest
Mind Awake
Spirit traveling

Projecting past the Sun and Moon
Traveling through the realm beyond boundaries
I am guided

Ancestors travel with me
Protecting me
Feeding my mind and spirit nourishment as I sleep
The energy of their presence is overwhelming
This multidimensional plane is their sacred space

Vibrant Soul

Like a lighthouse in the distance
I'm a light seen by all
Pointing you in the right direction

A bright beacon of hope
Guiding you to your destination
Like the Son of the Morning

I am the light of the illumination
A light that never dims
A light that will shine until the end of time

Come toward to the light
I have a great purpose
It is for the world to see

Enlightening this world with hope
Light of hope
Light of love
Light of tranquility

Mind Vibe

The heart is the strongest of the physical body
The mind is the strongest of the spiritual
The mind is the heart of the spirit

Control it
Strengthen it
Renew it

Negative energy attempts to penetrate
You must resist
Resist and it will not invade

Meditate for serenity
Meditate to shield your mind from stress
Meditate to shield your mind from anger

Control your emotions
Discipline your mind
Mind, body and spirit

I Am Who I Am

I Am Kentrel
I Am Unique
I Am Fearless

I Am Beautiful
I Am Perfection
I Am Wise

I Am Enough
I Am Art
I am Bi
I Am Black and Bold
I Am Who I Am

Our Existence

We all must adapt to life
Do our best
Whomever you pray to
God, Allah, Shiva, The Universe
Ask to be granted serenity to accept things you cannot change
Ask to be given the courage to change the things you can
And the wisdom to know the difference

Given a perfect world
Cherish it
Be kind to it

Each day won't be a peaceful one
But be grateful
Appreciate every minute of it until your very last
Make it meaningful
May there always be love, harmony and peace revolving around you

Me

Life itself is great
My life is fairly bland
But it belongs to me

I am not popular
I am not rich in money
But I am rich in self love, self knowledge, friendship and family

Even with family and friends, I stand alone
I walk alone
I am resilient

I am me
I don't desire to be anyone else but me
I am The Most High's unique creation

Serenity

There exists a place on Earth
Where one can find true peace
A place away from stress and pain
A place where all of it will cease

For some, its near the ocean
Where calmness is always found
The waves carry all the stress away

For others its the forest
That sets the mind at ease
The world feels completely still
Surrounded by tall trees
Smelling the fresh plants
Smelling sweet flowers
The smell of nature's fresh air

This brings serenity
Serenity within my mind
Serenity within my spirit

Often, we become stressed about the worries of the day
We forget to take care of ourselves
And take some time to get away

Whether you go alone or with someone you hold dear
Make sure you find the time you need
To make your head feel clear

Three Keys

You possess the keys
The keys to your mind
The keys to your body
The keys to your soul

Unlock and remove the chain of mental bondage
Open your 3rd eye
Let the innate compass within be your guide

Embrace your cleansed aura
Embrace your newly enhanced creativity
Let tranquility consume your soul

Aura

Sitting quietly with no distractions
15 minutes is all I need
Slowly inhaling and exhaling
Focused

Terminating negative thoughts
Focusing energy on the positivity in my life
Drinking hot green tea, soothing to my body
Conquering negativity
Relaxed

Early mornings
Walking outside feeling the warmth of the sun
Igniting my energy like a roaring fire

Healing my energy through vibrations
Binaural beats activating my brain
Awareness increased
I am relaxed
Anxiety is extinguished
Positive energy flows throughout my body

Root

I have a strong and secure connection with Mother Nature
Through my Root chakra I am grounded like the roots of a tree deep into the Earth
Energy flows through my roots, releasing my soul and restoring balance in my mind

My root connection nurtures my system
Healing this vessel
Constantly filling me with compassion

Wherever I am, I am safe and secure
I am stable
I am healthy body
Healthy mind
Abundant life

Anchored by the Earth
Supported by the Universe
I am secure and happy in my surroundings

Sacral

Walking along the edge of the water in the moonlight
Looking at my reflection
Knowing that I am enough

Flowing with the water
Feeling my emotions
Unleashing my joy and creativity into the world

I am emotionally open
Dancing to the music of life
Vibrating with every beat

Freely being myself
Accepting myself
Nurturing all aspects of myself

I am empowered
I am expansive
I am free

Solar Plexus

Advancing forward in my strength
Wholly believing in myself
Humble yet full of great pride

My afflictions transform into peace
My core is engaged
Fueled by the energy of the sun
Emanating Ra's rays of light

Trusting myself
Taking responsibility for my life
I know my worth

No guilt
No worry
No doubt
Self esteem is at an all time high

Heart

Breathing deeply
Air flowing through me with each breath
I am in a state of calmness

Inhaling kindness and purity
Exhaling fears and self limitations
Releasing all pain and all regrets

Heart full of forgiveness
Heart full of love
Soul is rich

I am happy
I am well
I am at peace

Throat

Speak up
Speak out
Speak truth

Unveiling my inner self through my compelling words
Empowering words
Like meditation to the mind, let your words be a
healing tool to the ears of the soul

Let your word be your bond
Let no secret has roll off your tongue
Rather not have a tongue than expose secrets of those
who trust me

I am honest with myself
Always inspired to be creative
Expressing who I am to the world unapologetically

3rd Eye

Vision is clearer than ever before
Finally awakened from this dream of reality
No longer a mental slave in this matrix

Seeing beyond
Visualizing all of what I could not
Trusting this eye

My awareness is constantly expanding
Granted more wisdom by God
Trusting my intuition and following it everyday

Living in a world with people with two eyes
In the land of the blind
It's my duty to speak the truth, spread knowledge and
awaken those asleep in the matrix

Crown

Right place
Right time
I am here

Being present in this moment is a gift
Being more aware
Having achieved higher consciousness

Clarity and enlightened wisdom
Linked to divinity
I have transcended beyond all limitations

I am a being of light and love
I am divinely guided
I live my life through my higher self
I am enlightened

Perspective of the Empath

A man believed that his empathetic ability was a curse because he could feel the pain of every person in the world. He felt their physical pain as well as their psychological. The man felt as if he was going insane then something extraordinary happened. Suddenly, the man began to feel everyone's joy and he stopped focusing his energy on their pain. Everyday he woke up he felt love, happiness and peace within his mind and spirit. He thanked the Universe for his empathetic gift.

The Day The World Meditated

A vast of majority of people in the world became overwhelmed with all the violence, death, and hatred. They came to an understanding that the world suffered under evil because too many people especially those in power needed to renew their minds and fill their spirits with positive energy. Nearly 8 billion people meditated for 30 minutes a day and that powerful energy was felt in every nation. They used sage to cleanse their aura and atmosphere around them. Positive energy consumed the world even when evil tried to exist it was overpowered.

Haikus

All is controlled by the mind
Change thoughts
Change life

Think positively
Speak positively
Positive outcomes

Gratefulness
Love
Forgiveness

Water dreams like plants
Starve your fears
Starve your insecurities

Attract positive energy
Attract love
Peace

Exercise your mind
Exercise your body
Meditate

Walk the Earth
Inhale nature
Exhale life

Don't force friendships
Don't force conversations
Don't force life

Energy
Balance chakras
Higher consciousness

Black and beautiful
Wise and conscious
Me

All have times of fear
All have times of guilt and anxiety
These times must be overcome

One chapter ends
Another one begins
The story never stops
Keep Pushing

Be present, live and love the now
Appreciate what you have before it's gone
Find joy in the ups and downs

Attitude is a boomerang
Throw it out into the world
It comes back to you

Improvement is never easy
Although uncomfortable
Strive to always improve
Own your life choices
Both good and bad
Take responsibility

Remain humble
Remain hungry
Own your everything

Know who you are
Embrace it
Strive to evolve

All fail at something
Don't stress
Press forward

Enjoy life
Laugh
Let joy enter your soul

Accept what it is
Let go of what it was
Have faith in what it will be

Abundance is coming
Accept it
You deserve it

Higher thoughts
Higher energies
Higher vibrations
Rise up

111
Thank you for my spiritual awakening
I am aware of my purpose
The time for manifesting is now

222
I have no worries
Everything is working in my favor
I trust the path that I am on

333
I am great in hands
You watch from above
Guiding me

444
You're surrounding me
I feel your presence
Keeping me focused

555
Major shifts taking place
Trusting the process
Excited about it all

666
Spiritual being
Seeking refocusing from human experience
Seeking spiritual reconnection

777
Blessings upon blessings
Spiritual path widening
I will continue

888
Financial abundance on the path
I desire it
It is mine

999
I must complete
Almost finished
Next step will elevate me

1111
The doorway is open
I hear you great angels
I am vibrating higher

000
One with the Universe
New beginnings
Creator of my own destiny

www.ingramcontent.com/pod-product-compliance
Lightning Source LLC
Chambersburg PA
CBHW072311170526
45158CB00003BA/1278